A Mark Dahle Portfolio

When The Trolls Moved

Mark Dahle Portfolios can be read in a few minutes and enjoyed for a lifetime.

This portfolio includes a story about a group of trolls moving to Norway, a photo of a colorful 36 x 24 inch painting (at the right) and twenty-five construction photographs from Basel, Switzerland.

Unlike many picture books, the text is unrelated to the paintings and photographs. This might seem a little weird at first. One thing that helps is to order more portfolios until you finally get used to it. In the meantime, you may draw your own pictures of hideous trolls on the pages if you like.

Photographs in this book are available in limited editions. See http://www.MarkDahle.com for more information and for previews of upcoming portfolios.

© Mark Dahle 2012. All rights reserved.

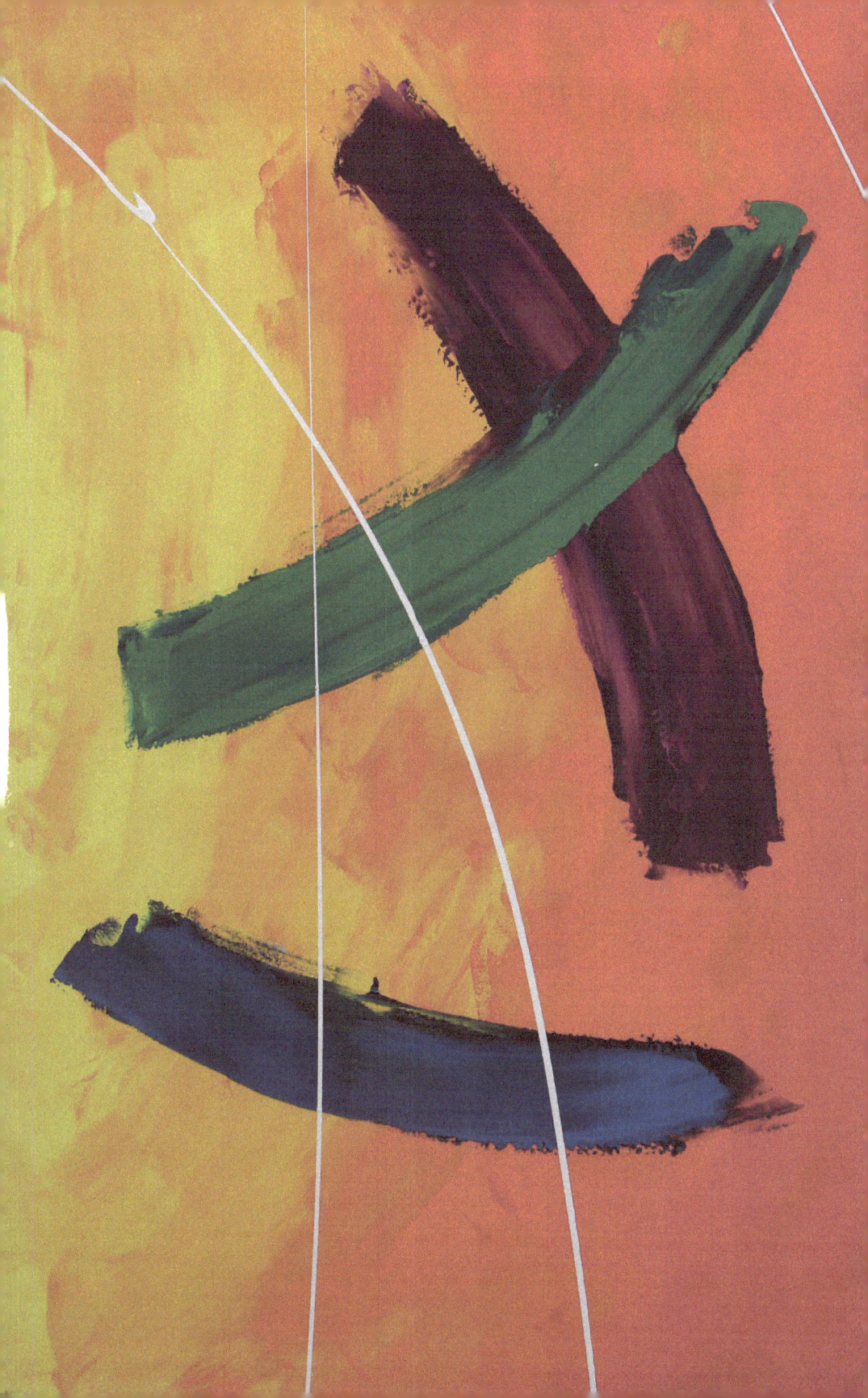

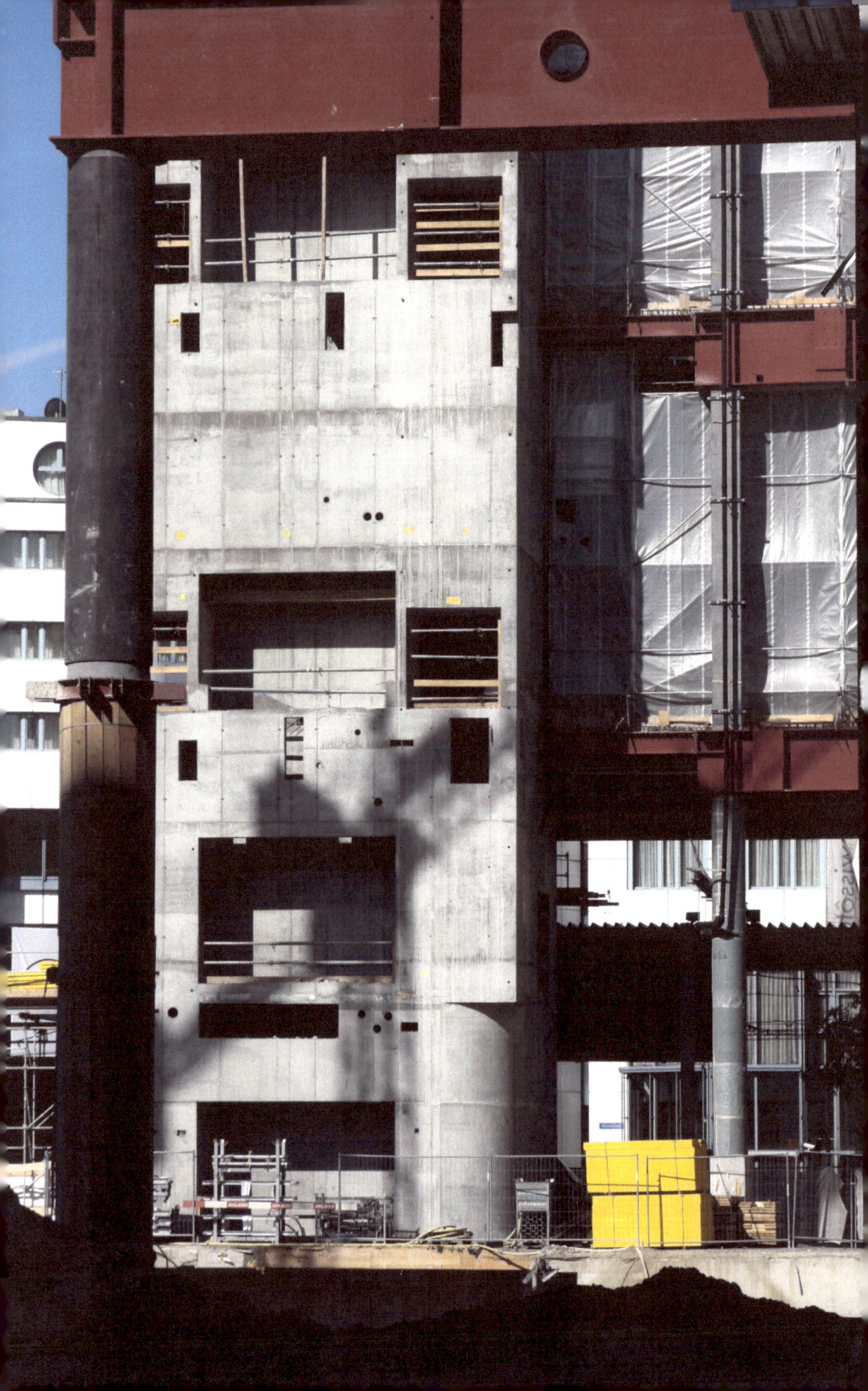

~ ~ ~

Once, long before the man in the moon had whiskers, the trolls moved to Norway to live with the Vikings.

The trolls packed all they could in bags and carried them on their backs.

The troll who packed the piano was unhappy for most of the trip.

When the trolls moved, ABC school had to be canceled.

ABC school doesn't teach troll children *all* the letters, just A, B, and C.

They think that is very difficult.

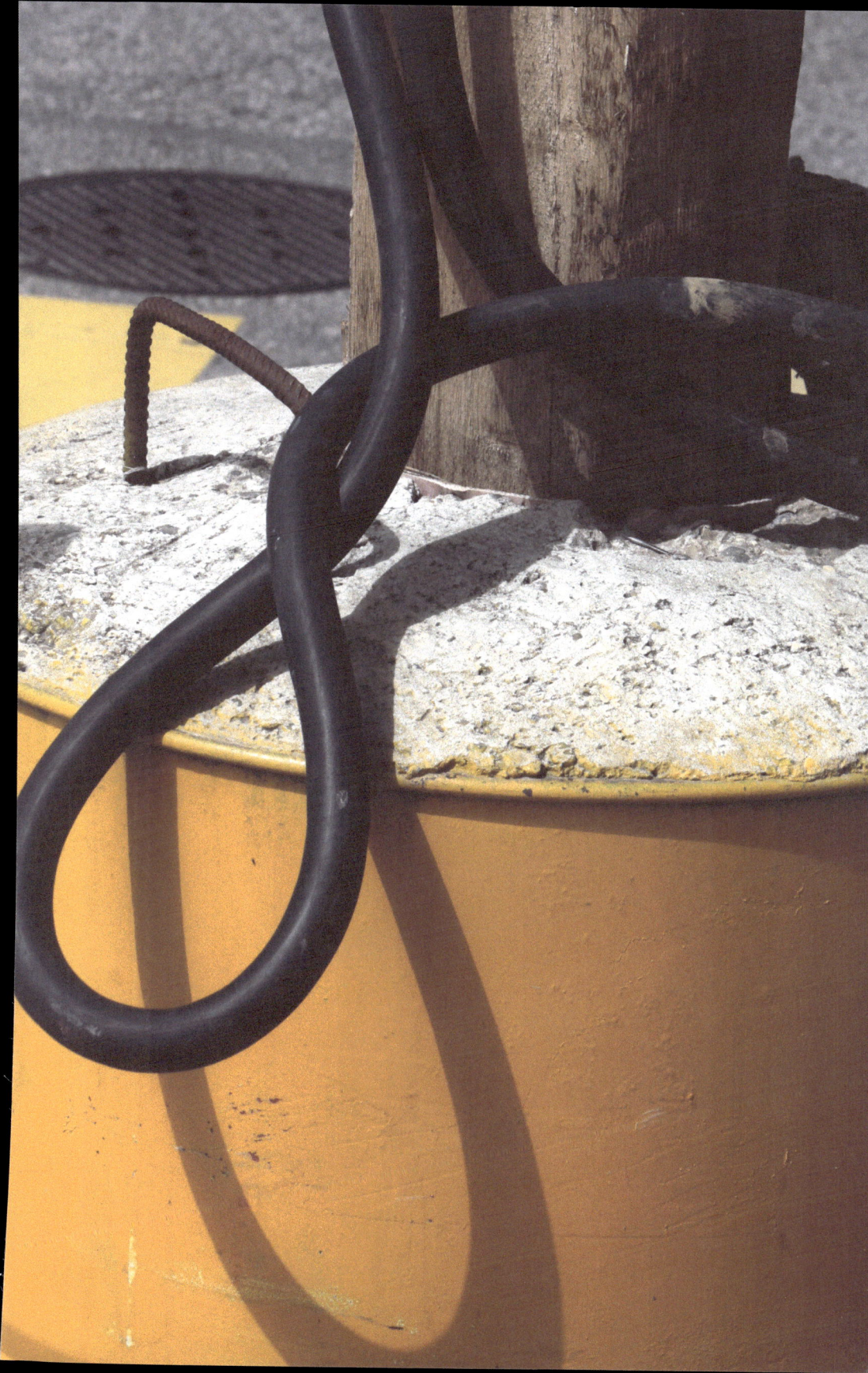

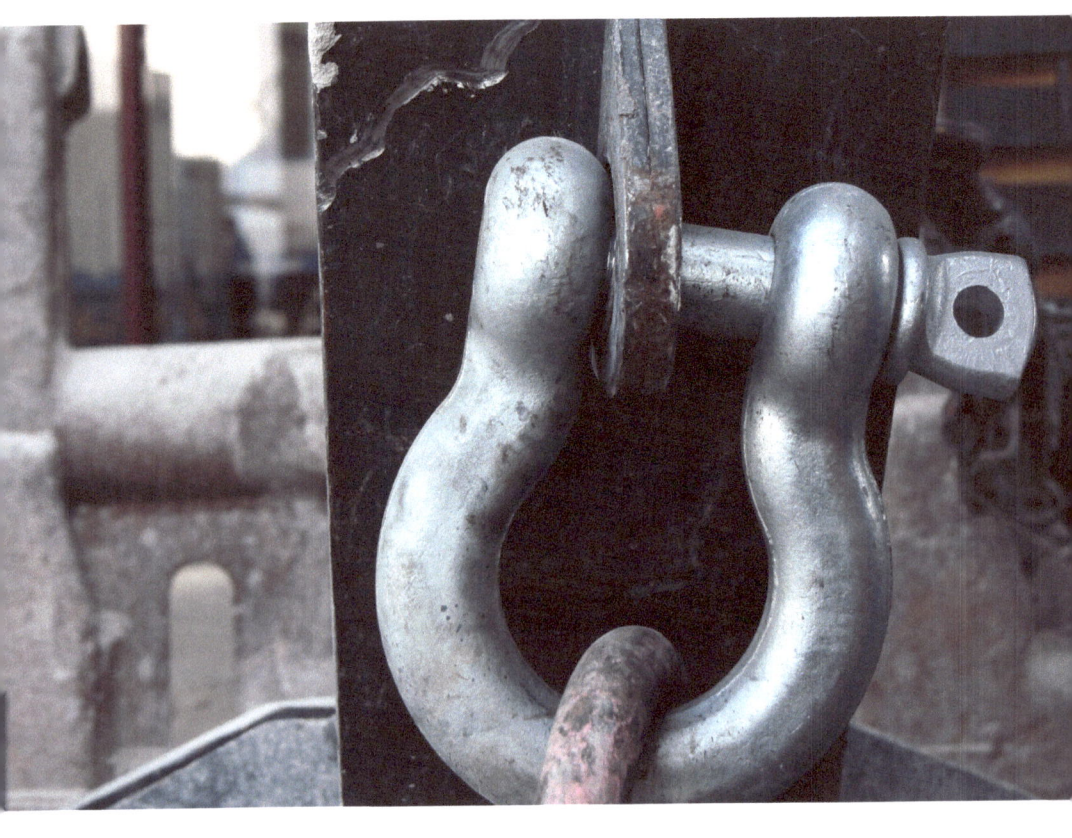

When ABC school was canceled, the troll children were very happy.

The troll teacher, who could barely walk most of the time, turned cartwheels.

When the trolls moved, they forgot to pack their toothbrushes. Along the way they had to use evergreen branches from trees instead.

None of the trolls looked any better with pine needles stuck in their teeth.

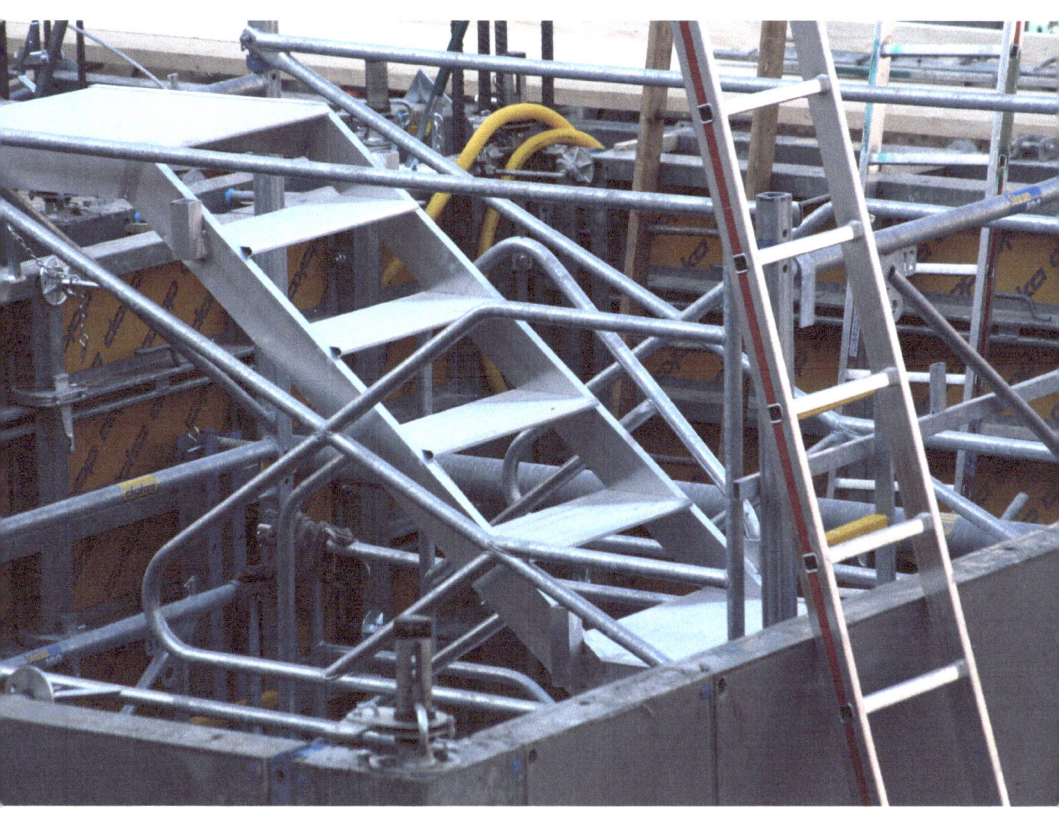

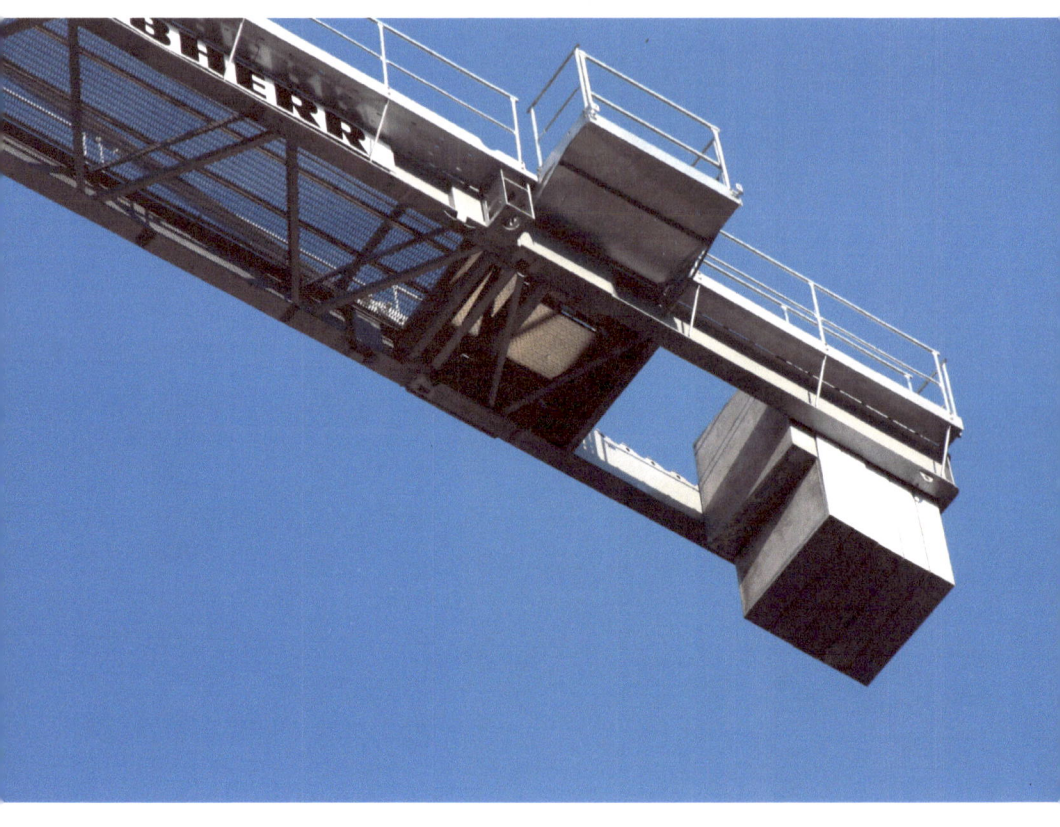

When the trolls moved, they had to pass through a large forest.

The trees and the trolls kept bumping into each other, and it was no fault of the trees.

Trolls in the woods can normally be very quiet and keep out of sight.

But they're easy to spot when they're moving in a group because the piano makes strange noises every time it hits a tree.

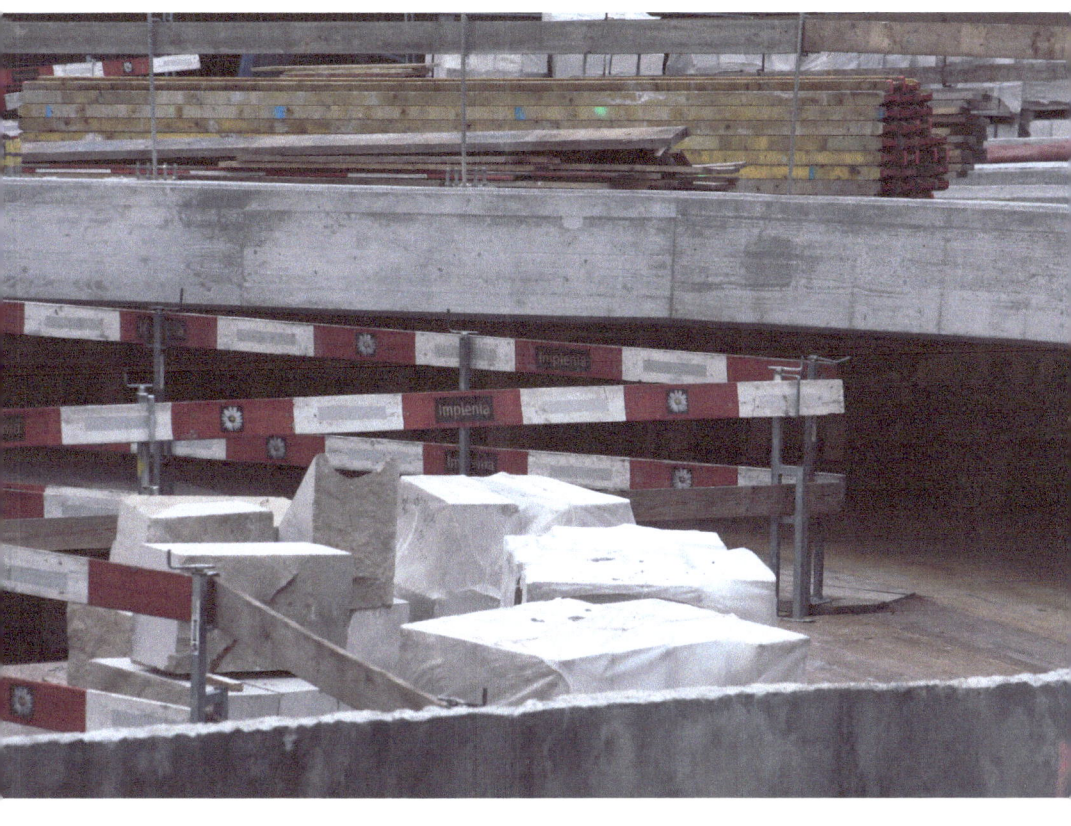

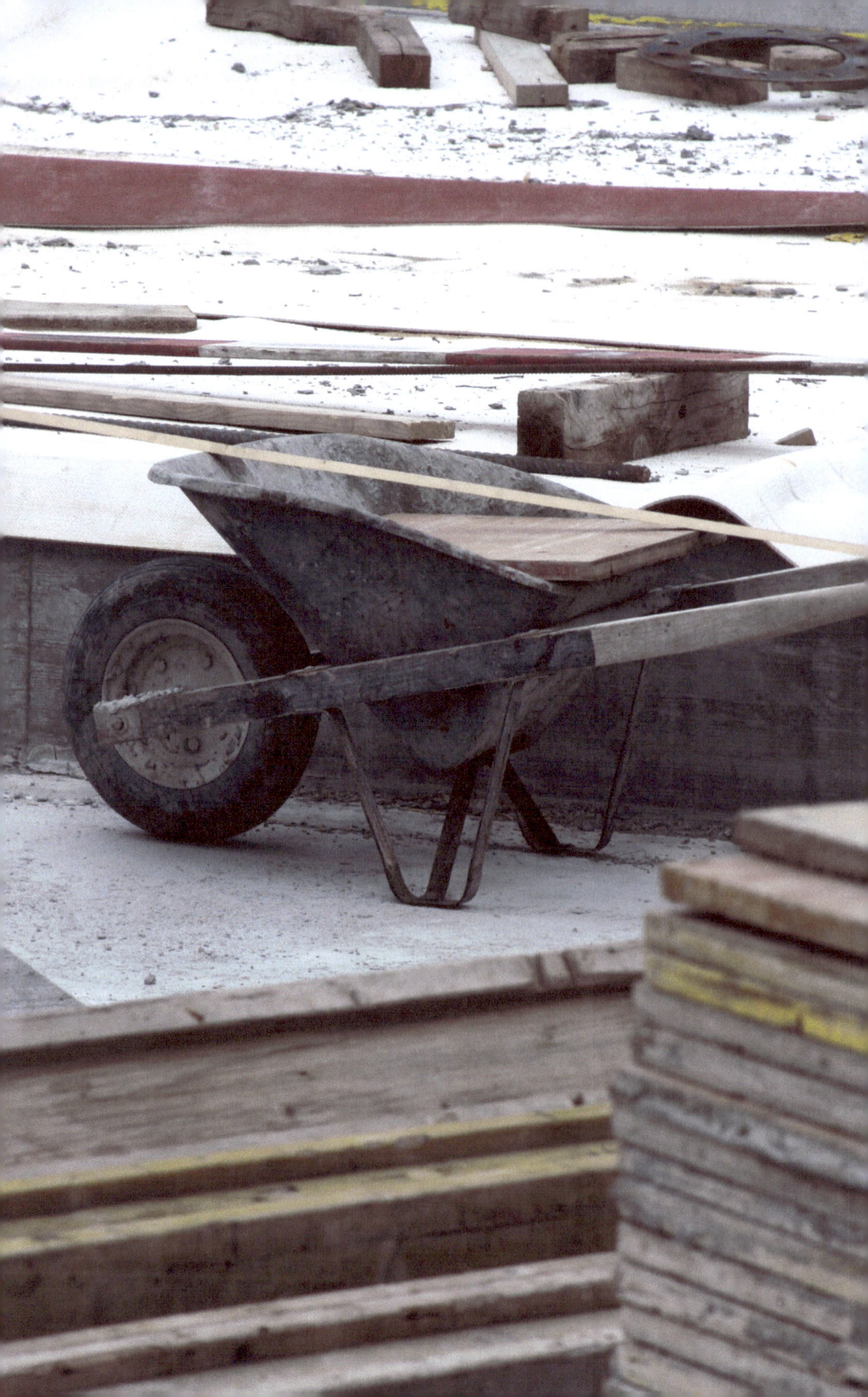

When trolls eat breakfast, they put the cow on the table right beside the salt and pepper shakers, to make it easier to get milk.

Troll children never knock glasses of milk onto the floor, but sometimes they knock the cow over.

The cow hates this.

When the trolls moved, they left home on a day so hot that chickens were laying hard-boiled eggs. All the trolls left their raincoats at home.

After two days, it started raining.

All the trolls were miserable without their raincoats, and they blamed it on the chickens.

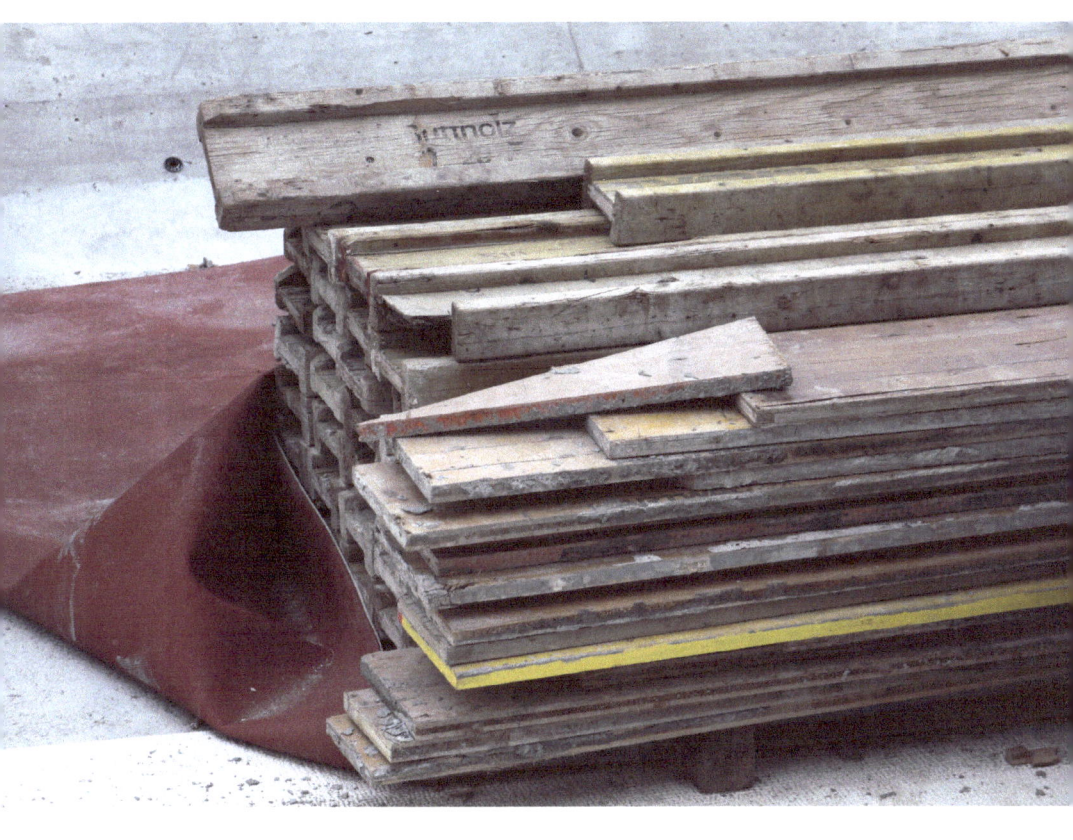

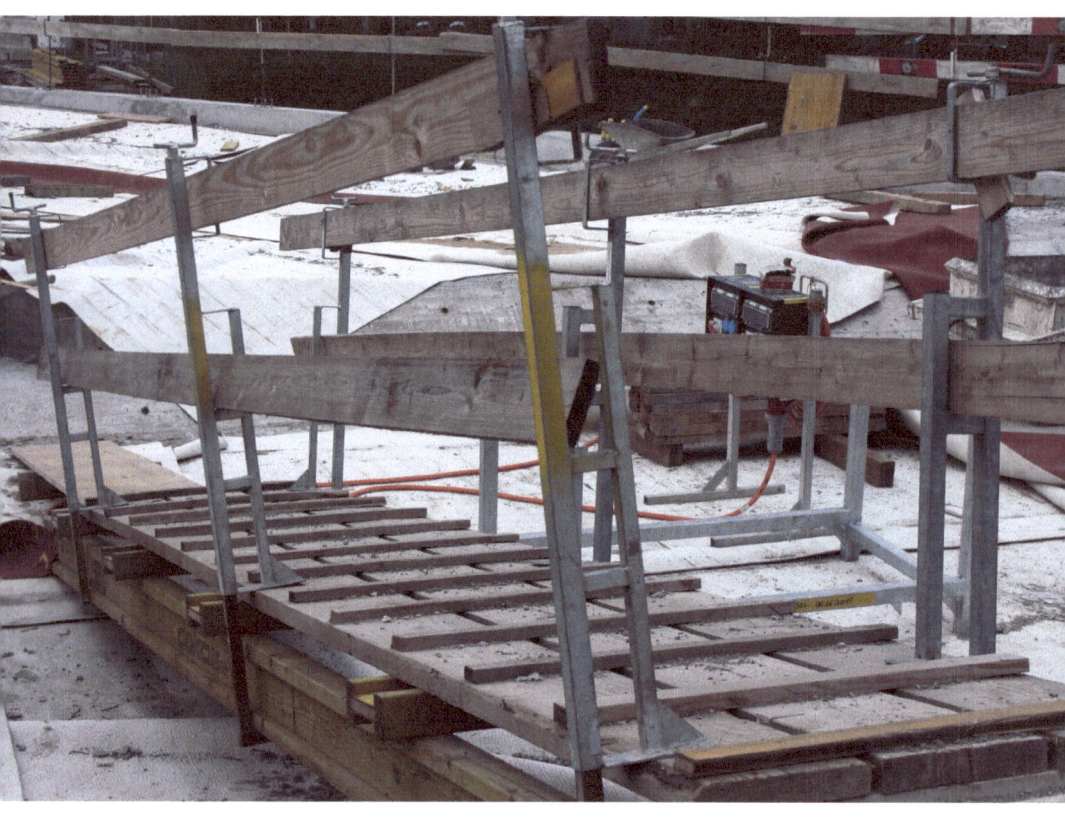

When the trolls moved, the little trolls splashed the big trolls every time they came to a mud puddle.

The little trolls thought it was funnier than a cow being tickled.

The cow thought so too.

When the trolls moved, they ran out of cookies.

They had a contest to see who could make cookies out of vegetables.

The trolls tried broccoli chip cookies. And cauliflower drops. They even tried Brussels sprout swirls. But nobody won the contest.

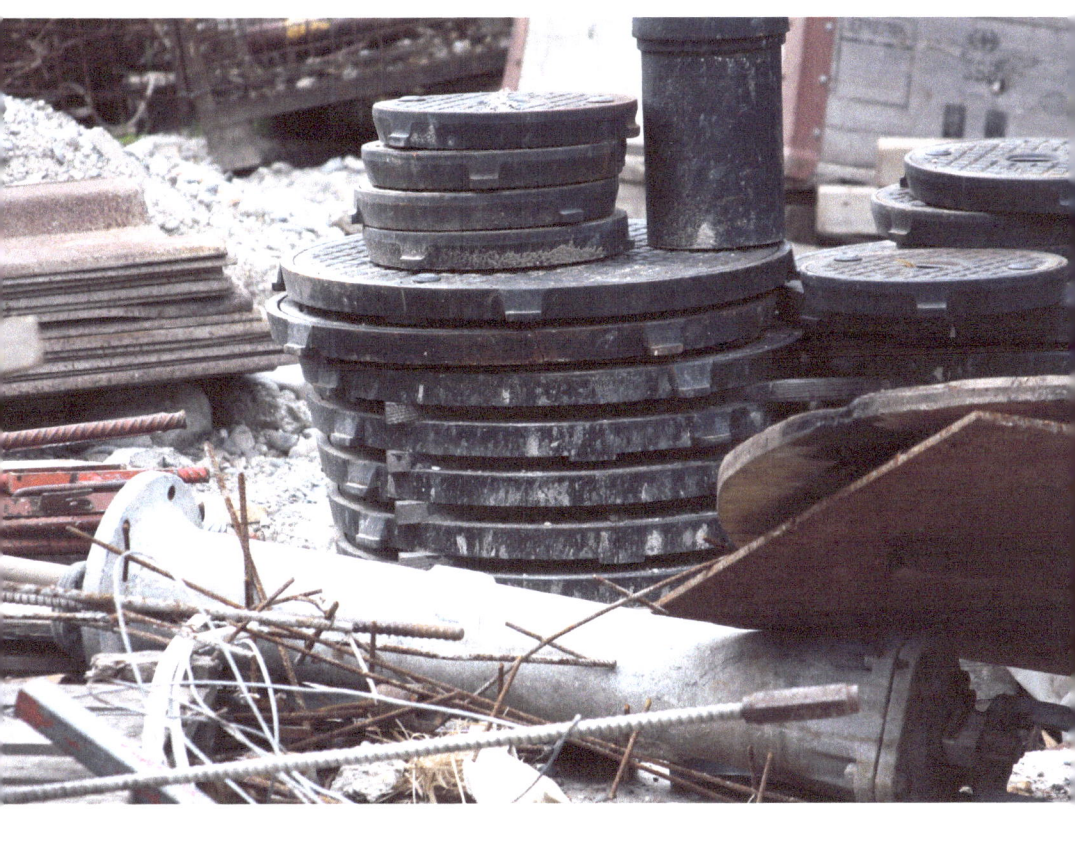

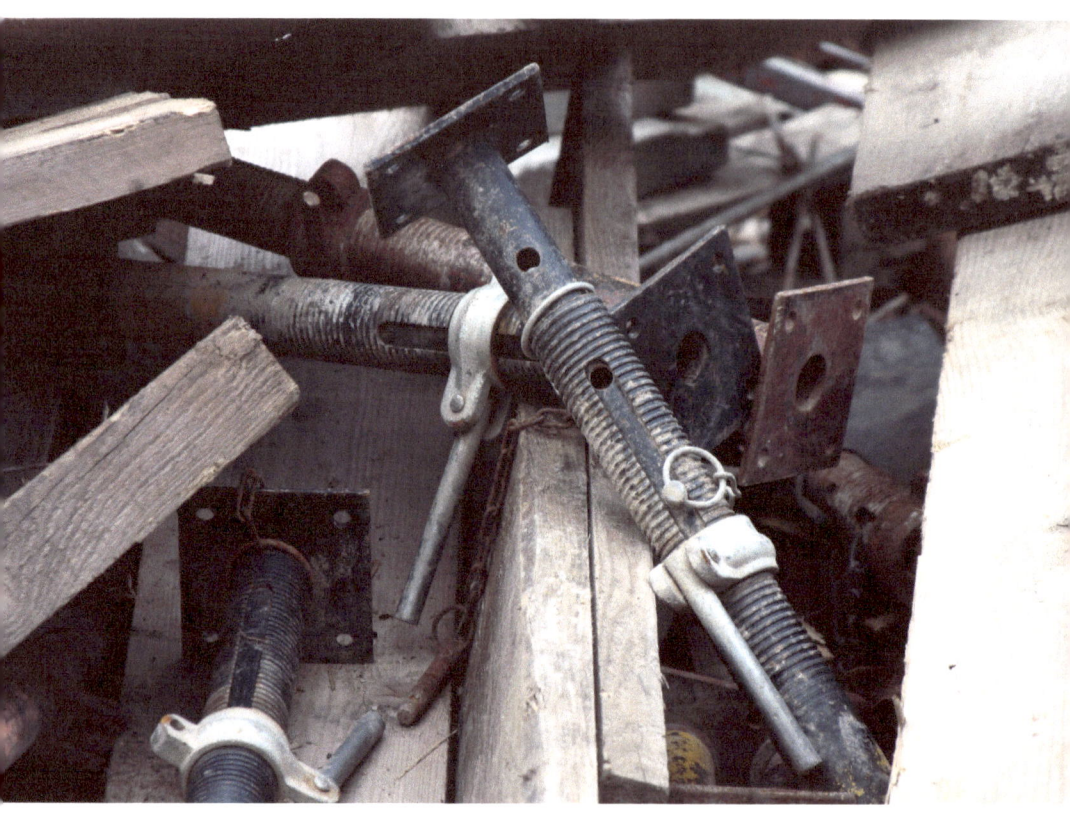

When the trolls moved, they thought they'd never make it all the way to Norway.

"We'll never get there if all these trees keep bumping into us," they complained.

When the trolls moved, they tried to catch fish to eat.

They used Brussels sprout swirls and broccoli chip cookies for bait.

The fish didn't like the cookies any more than the trolls did, and the trolls didn't get a nibble.

One troll on the trip was so cheerful that she made all the other trolls grumpy. The cheerful troll would say things like, "Keeps the forest green, doesn't it?" when it was raining so hard no one could see.

The trolls would throw their shoes at the cheerful troll whenever she said things like this.

Soon most of the trolls were barefoot.

Somehow the chickens got blamed for this, too.

The troll doctor had to bandage so many sore feet he had no time to play golf.

Finally he quit and became an ear specialist.

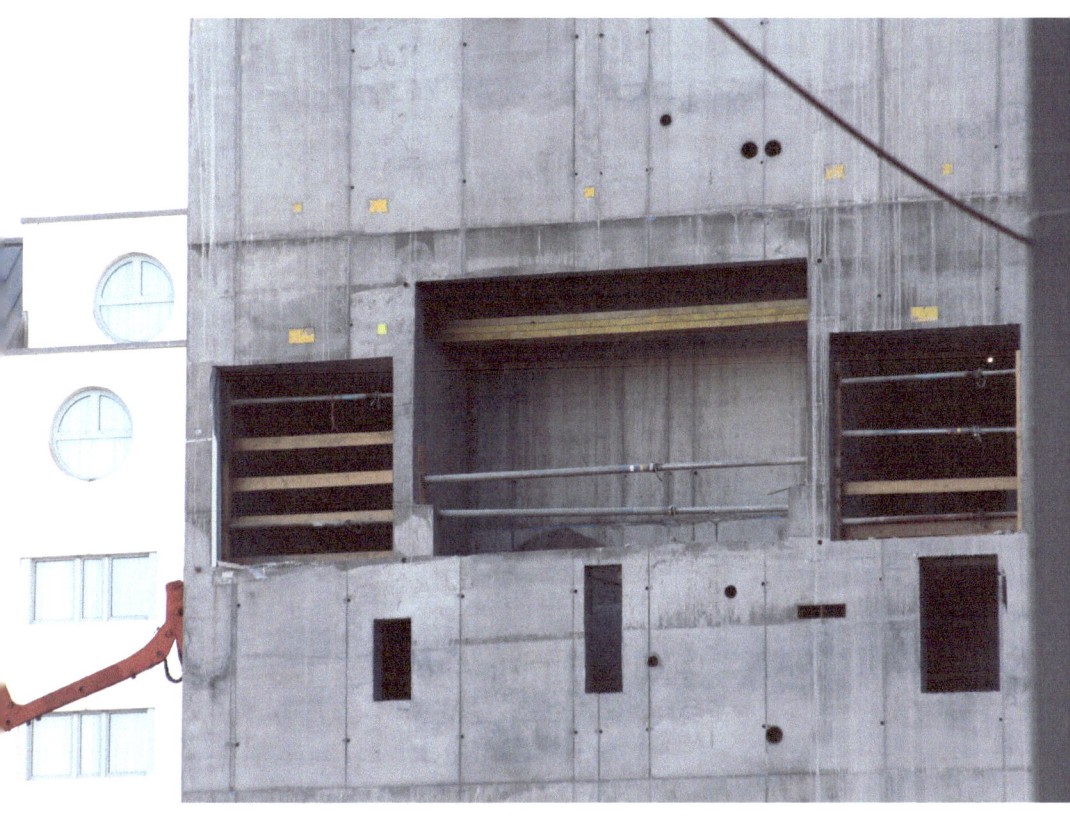

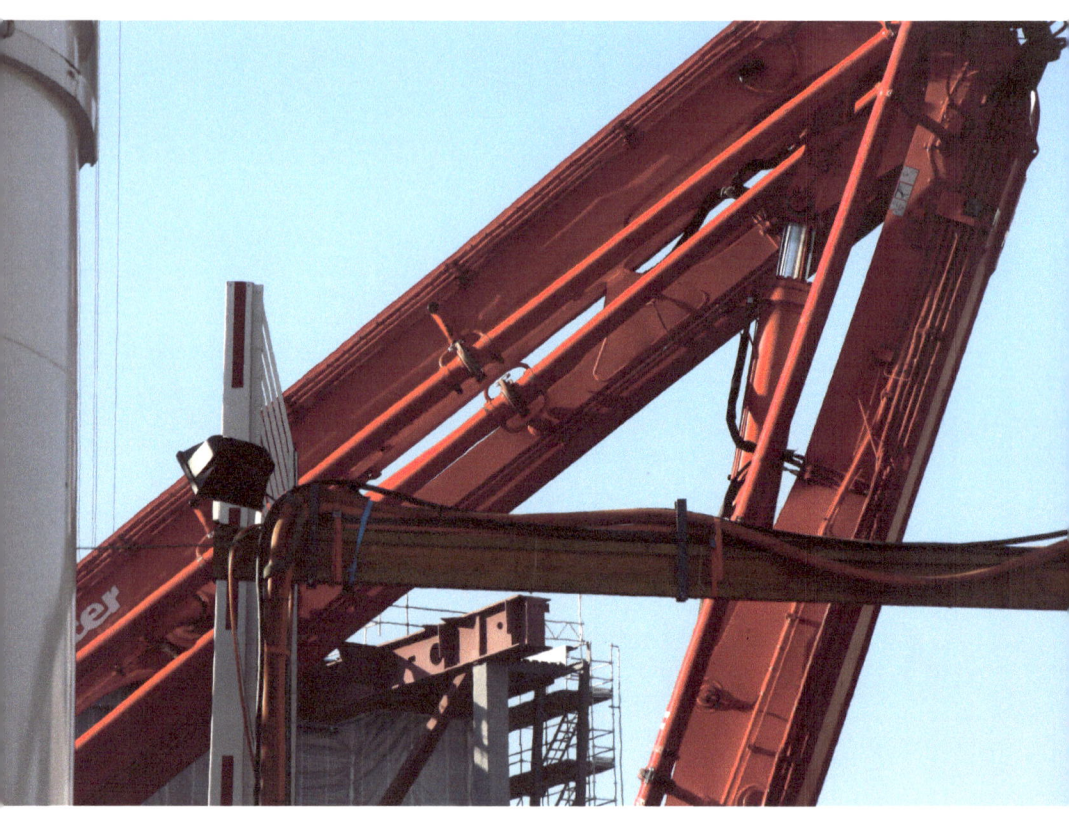

When the trolls moved, they would sit around campfires at the end of the day. The cheerful troll tried to get them all to sing songs.

The sound was so frightening the moon hid behind the clouds for two years, and the ear specialist started to wonder if he should try something else.

When the trolls moved, the troll carrying the dishes was the only troll who fell down more than once.

Every week he fell and broke the dishes, and each week the trolls had to get new ones.

He was finally asked to carry the Brussels sprout swirls instead. Nobody cared if *they* got broken.

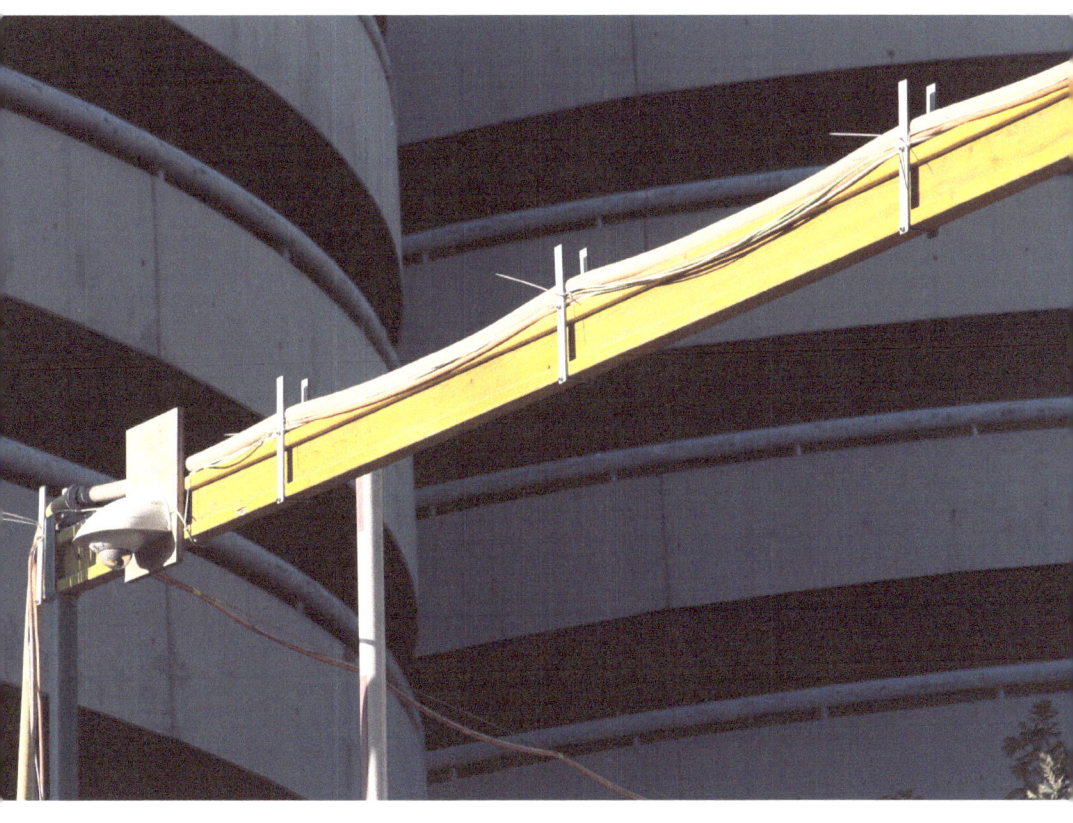

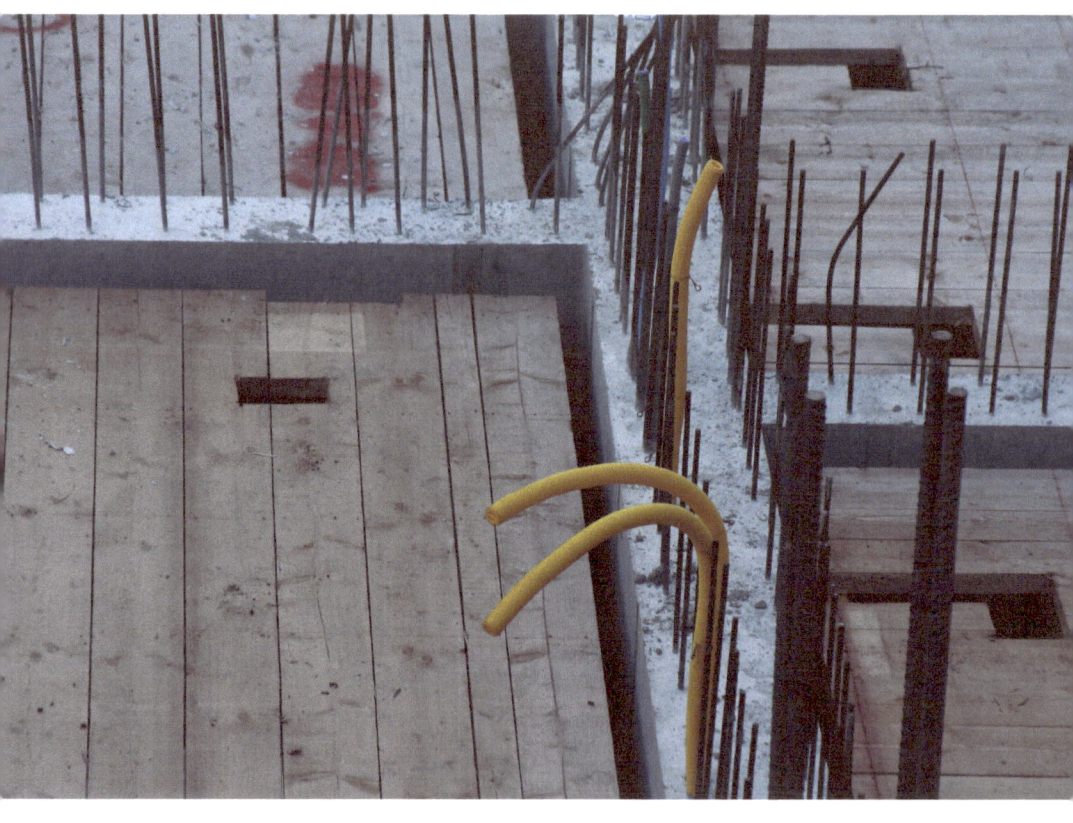

When the trolls moved, they did not bring a map. "We're clever, and we won't get lost," they said.

They got lost so many times they passed the South Pole twice.

"I don't think we'll ever get to Norway!" said the ear specialist, who had lost all his golf clubs when a tree bumped into him.

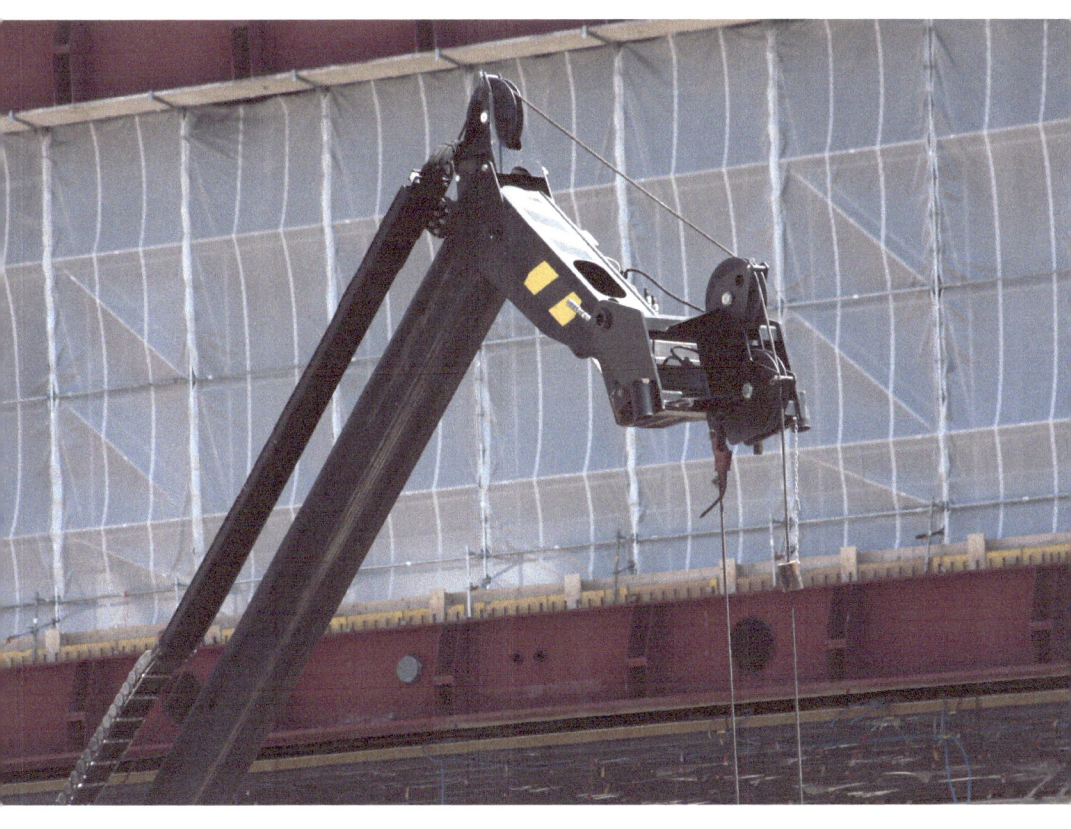

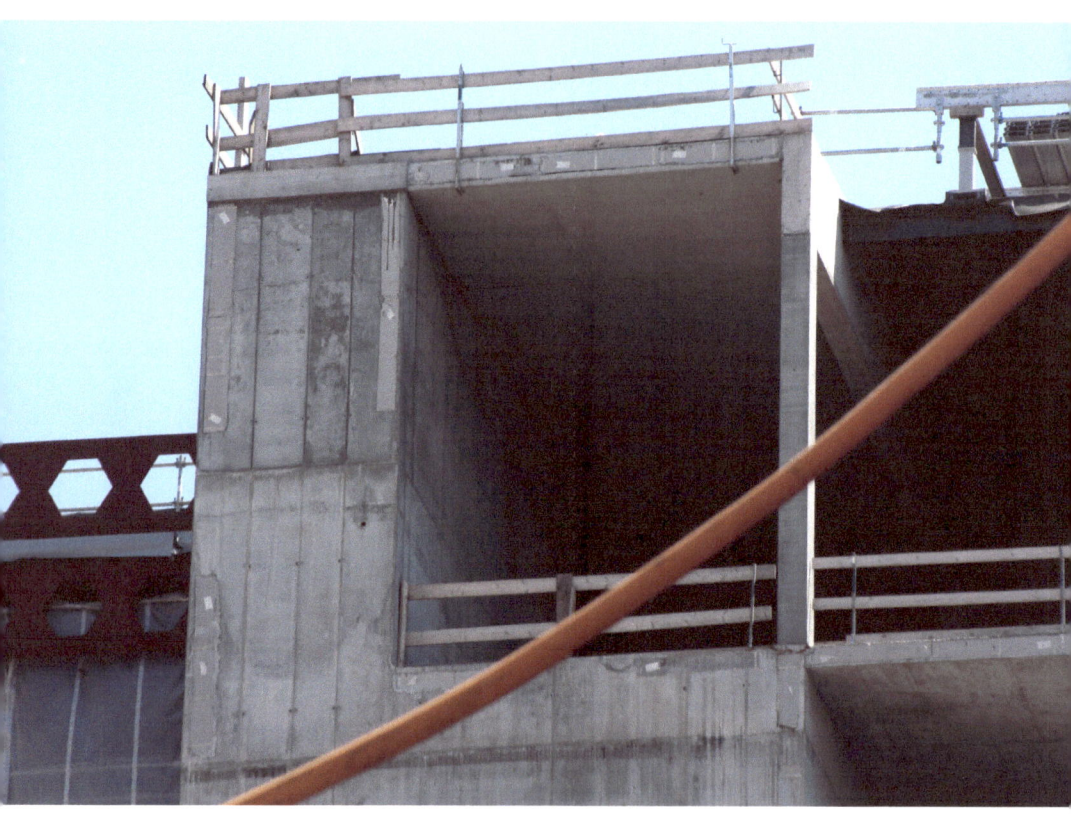

When the trolls moved, the troll children kept asking, "Are we there yet?" when, quite plainly, they were not.

When the trolls moved, they thought they'd never make it all the way to Norway.

But they did.

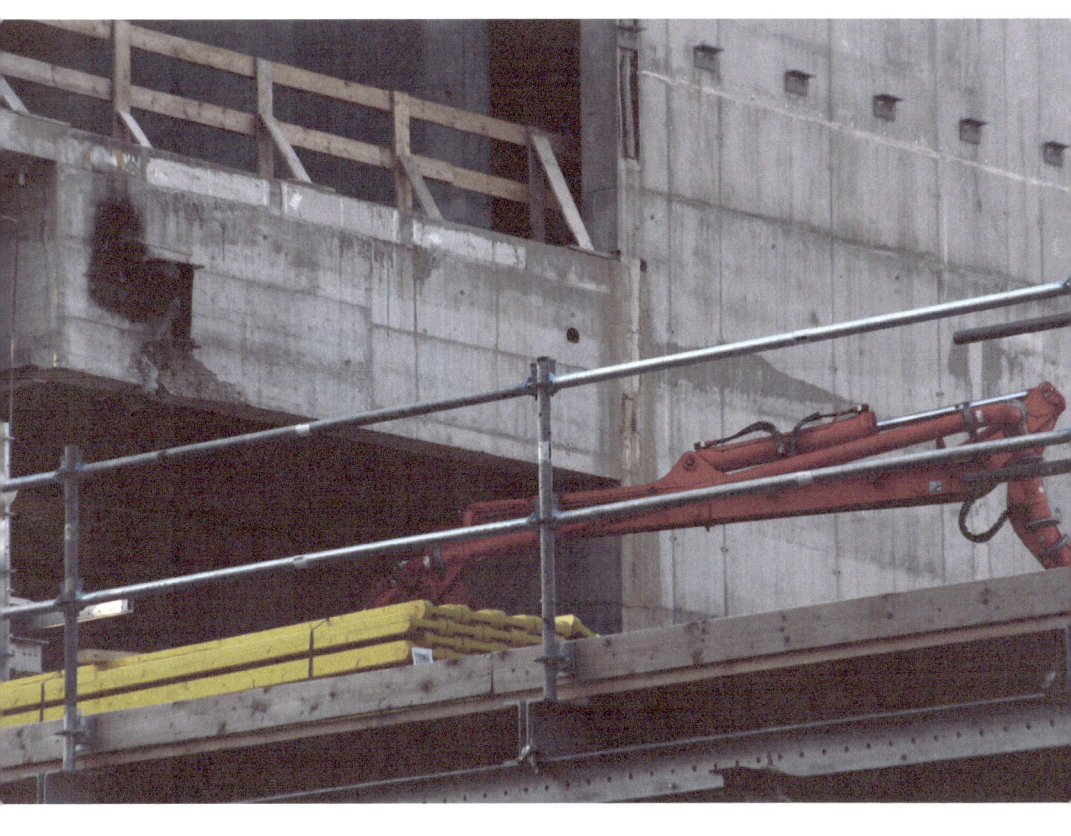

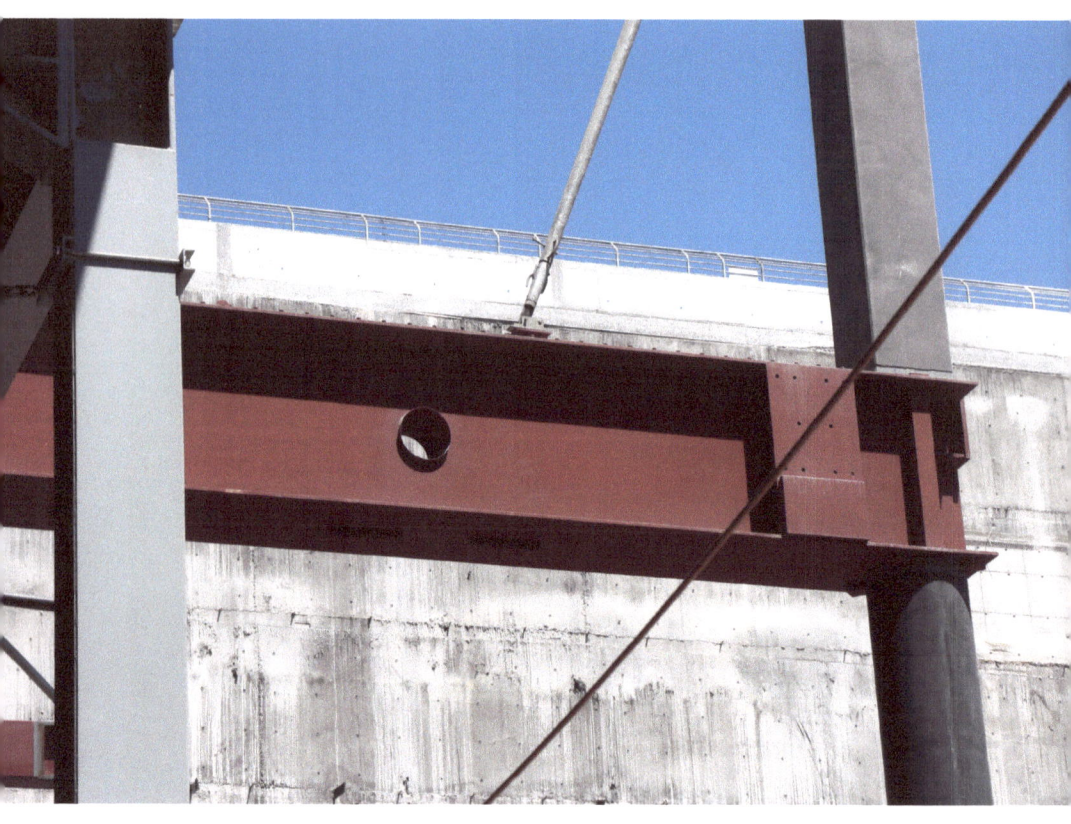

The troll with the piano was the first to unpack.

The troll who was the school teacher was the last.

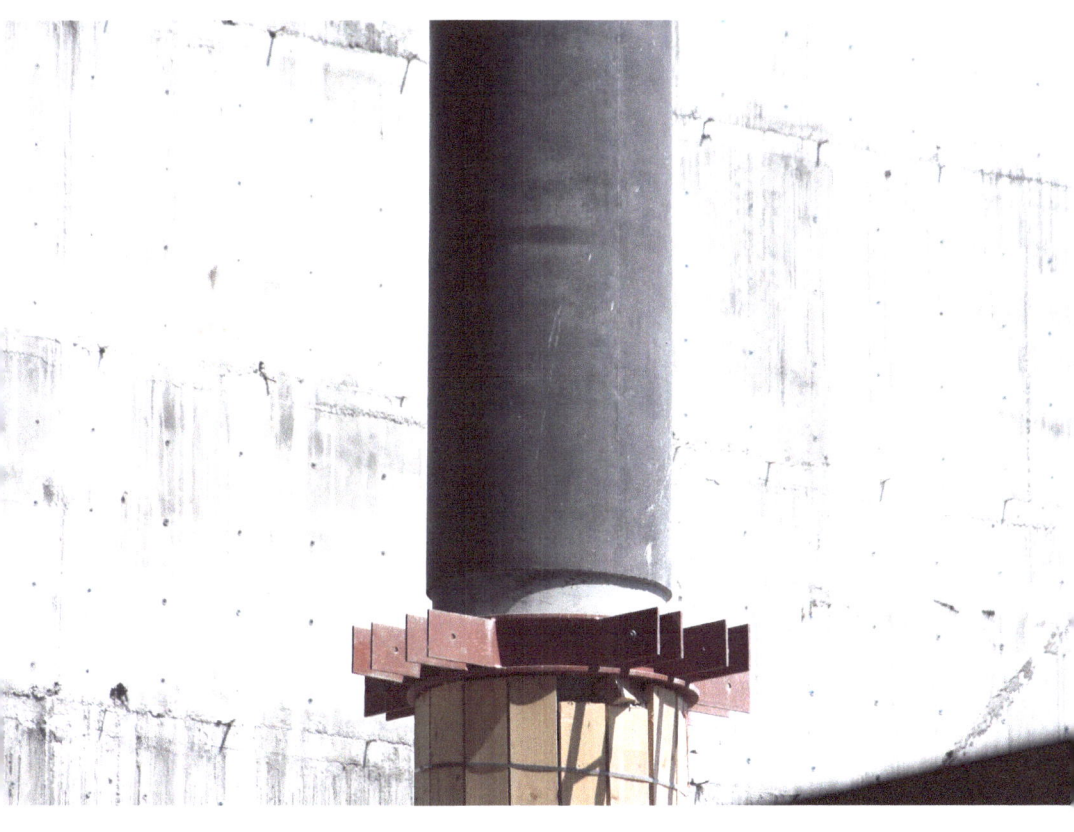

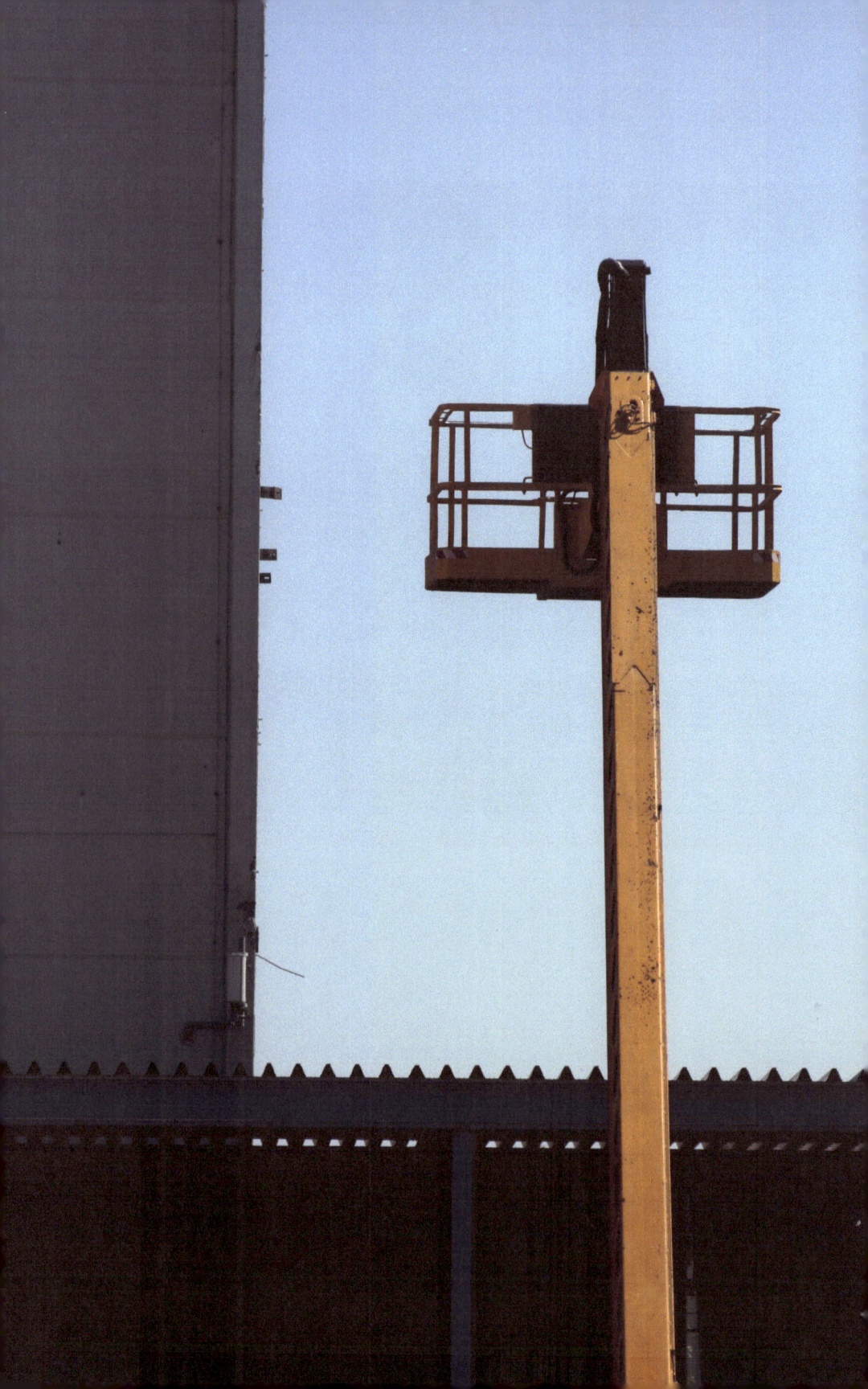

The ear specialist went back to his regular practice and headed for the golf course.

The other trolls hiked to the nearest town and bought toothbrushes, shoes and cookies from the Vikings.

Mostly they bought cookies. And not one of the cookies was made with Brussels sprouts.

~ ~ ~

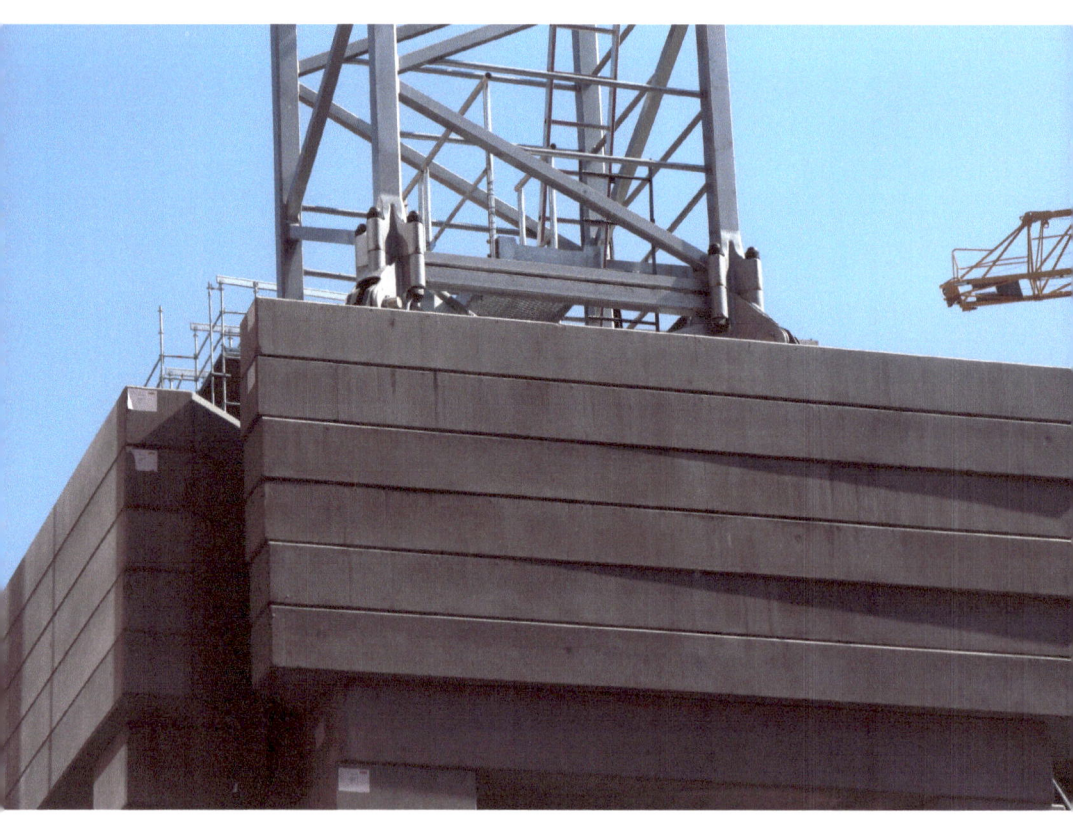

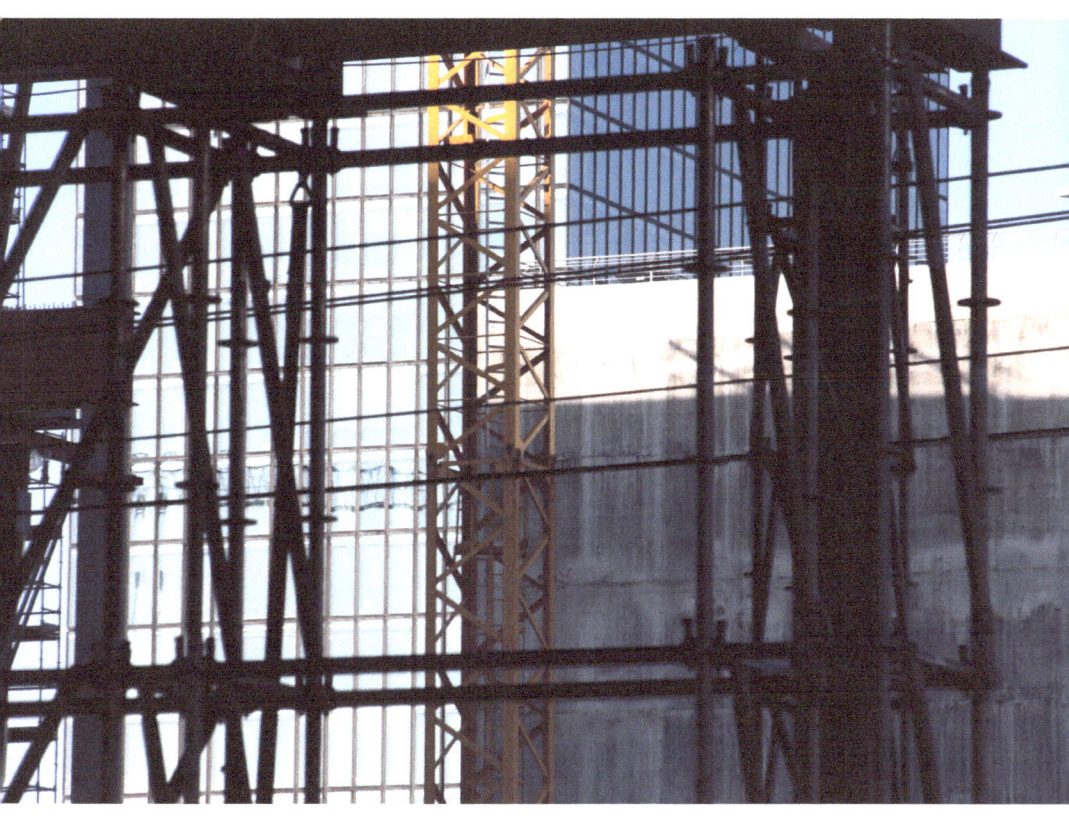

A Mark Dahle Portfolio

One Day's Encouragement

This Mark Dahle Portfolio includes a beautiful abstract painting, twenty-eight outstanding industrial photographs from Orlando, FL, and from the area around Columbus, OH, and a biographical essay titled One Day's Encouragement.

Thank you to all the coaches and leaders shouting encouragement to people doing their best.

Sometimes one day's encouragement can make a lifetime of difference.

A Mark Dahle Portfolio

Any Pet I Wanted

This Mark Dahle Portfolio includes a colorful abstract painting, twenty-four beautiful photographs taken near train tracks in Grand Rapids, MI; Palm Springs, CA; and San Ysidro, CA, and a children's story, Any Pet I Wanted.

 Mom and Dad said I could have a pet.
 Any pet I wanted.

 My Mom was hoping for a lop eared bunny.
 My Dad was thinking of an English sheep dog.
 I wanted a dragon.

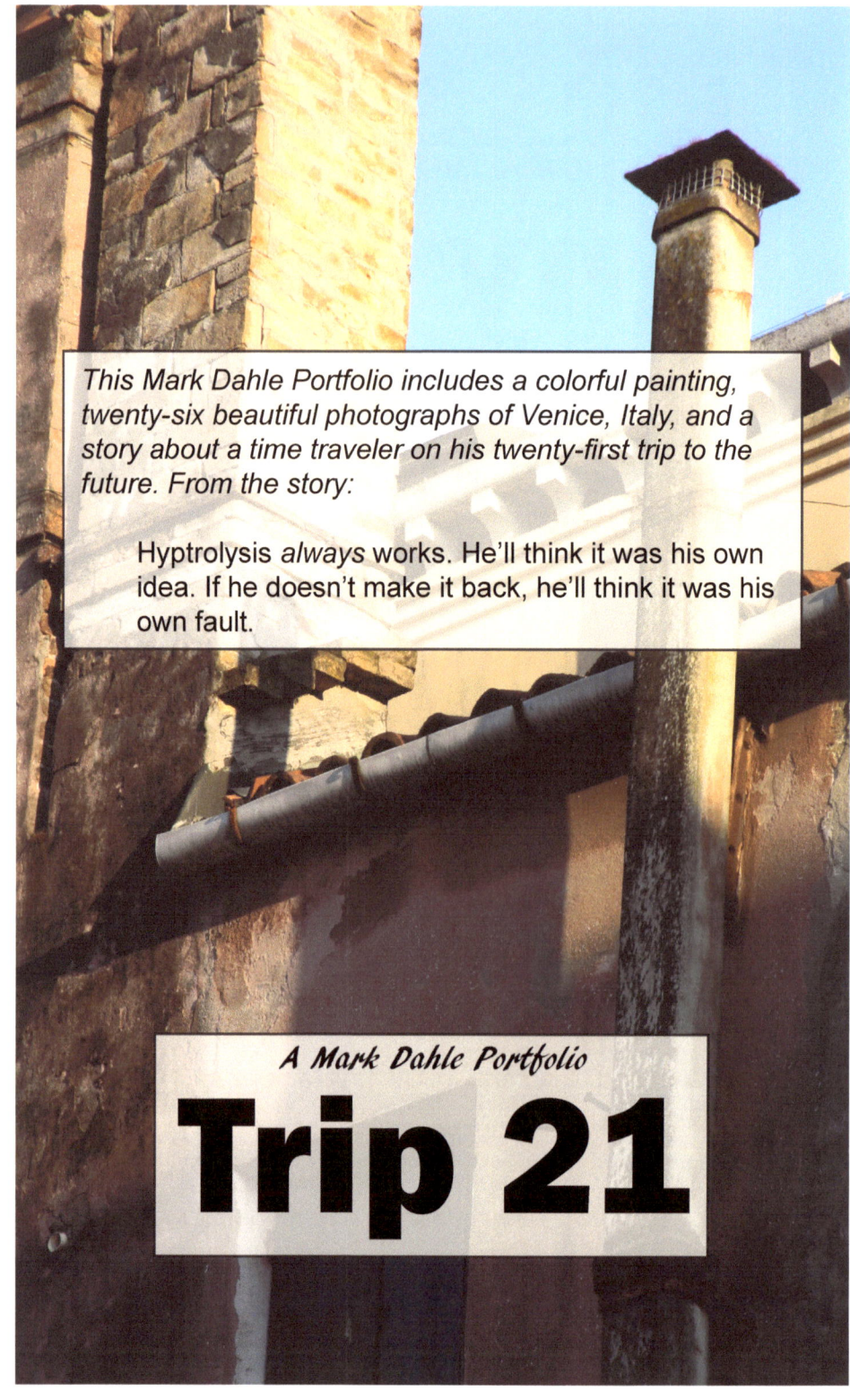

This Mark Dahle Portfolio includes a colorful painting, twenty-six beautiful photographs of Venice, Italy, and a story about a time traveler on his twenty-first trip to the future. From the story:

> Hyptrolysis *always* works. He'll think it was his own idea. If he doesn't make it back, he'll think it was his own fault.

A Mark Dahle Portfolio

Trip 21

www.ingramcontent.com/pod-product-compliance
Lightning Source LLC
Chambersburg PA
CBHW041109180526
45172CB00001B/177